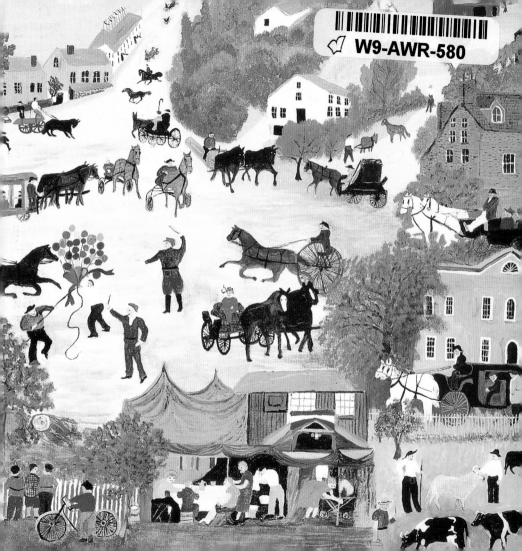

THE ESSENTIAL ™

Grandma Moses

●———————————●

BY JANE KALLIR

THE WONDERLAND
PRESS

Harry N. Abrams, Inc., Publishers

THE WONDERLAND PRESS

The Essential™ is a trademark
of The Wonderland Press, New York
The Essential™ series has been created by The Wonderland Press

Series Producer: John Campbell
Series Editor: Harriet Whelchel
Series Design: The Wonderland Press

Library of Congress Control Number: 2001087911
ISBN 0-8109-5822-8

On the endpapers: Detail of *Country Fair,* Kallir 921

Unless otherwise noted, all works are oil on pressed wood (Masonite™)
Unless otherwise noted, all works are by Grandma Moses and are in private collections
All works are courtesy Galerie St. Etienne, New York, NY

Printed and bound in Hong Kong

PHOTOGRAPH CREDITS: Geoffrey Clements: *Checkered House; Wash Day; A Beautiful World; The Spring in Evening; Joy Ride.* Eric Pollitzer: *Sugaring off in Maple Orchard; Catching the Thanksgiving Turkey; Hoosick Falls, N.Y. II; Christmas at Home; Grandma Moses Going to Big City; Hoosick Valley (From the Window); The Old Oaken Bucket; The Dividing of the Ways; The Thunderstorm; The Dead Tree; July Fourth; Calhoun.* Jim Strong: *The Covered Bridge; The Fireboard; The First Automobile; Black Horses; The McDonnell Farm; Picnic; A Tramp on Christmas Day; In Harvest Time; A Storm is on the Waters Now; Apple Butter Making; The Mailman Has Gone; Country Fair; The Departure; Barn Dance; Halloween; So Long Till Next Year; The Doctor; The Childhood Home of Anna Mary Robertson Moses; Mount Nebo in Winter; Little Boy Blue; Rockabye (Self-Portrait); Corn; Sugar Time; Rainbow; Taking in Laundry; Mountain Landscape.*

Harry N. Abrams, Inc.
100 Fifth Avenue
New York, NY 10011
www.abramsbooks.com

Contents

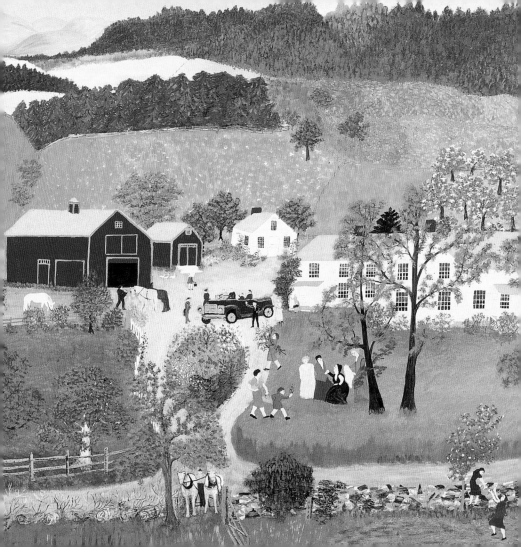

Grandma *who*?

She was America's favorite grandma, but who was she? (Hint: We're not talking about Granny on *The Beverly Hillbillies* TV show.)

Anna Mary Robertson Moses, better known as **Grandma Moses** (1860–1961), was arguably the greatest American folk painter of the 20th century. She was one of the first women artists to become a media superstar and the first American painter to achieve a significant international reputation in the post–World War II era. Most people know her name, but can't quite place her. They wonder: Was she a real person? When and where did she live? Who was she?

OPPOSITE
Detail from
*Grandma Moses
Going to Big City*
1946
Oil on canvas
36 x 48"
(91.44 x 121.92 cm)
Kallir 557

Sound Byte:

"My granddaughter out in Arizona jokes a lot about [the Christmas cards], she says I am a witch, except I ride around the country on a paint brush instead of a broom."

—GRANDMA MOSES, *My Life's History*, 1952

Between the end of World War II and her death in 1961, at the age of 101, Grandma Moses was so famous that she became a kind of legend. Even today, few women artists can match her when it comes to success

and renown. Yet, adored by millions, she was sometimes dismissed by a postwar art world that thought serious American art should be difficult and abstract.

> *FYI:* **Typos or grammar mistakes?**—Grandma Moses had little formal education, so it's natural that her writing contained errors in grammar, punctuation, and spelling. There is, however, great charm in her unschooled language; it reveals the honest, earnest, unpretentious, shoot-from-the-hip attitude she had toward life and the world around her.

Grandma Moses's paintings look simple, but they're not. She spent her entire life on farms, in upstate New York and rural Virginia, and painted the landscapes that she knew and loved best:

- the changing seasons and weather;

- rolling hills and bountiful crops;

- humankind in harmony with nature.

Moses had never been to art school. In fact, she received little formal schooling of any kind and had never visited a museum. She was over 70 when she first began painting seriously and became an artist. Grandma Moses invented one of the most influential, original styles

of any self-taught painter, ever. Many artists later imitated her, and the "Grandma Moses Style" was adapted for everything from old-time prints to china patterns to children's-book illustrations. Of course, before Grandma Moses, there was no such thing as the Grandma Moses Style. And afterward, there was never an artist quite like her.

What is Folk Art?

Folk art is literally the art of the people—of the *folk*. The concept originated in Europe, where there was a sharp division between artists who trained formally at the academies and painted for rich aristocrats, and artisans who worked for the peasants creating decorative pottery, furniture, and devotional objects. Folk artists, most active in the pre-industrial era, served the latter group.

- Folk art conforms to traditional patterns that are handed down from generation to generation.

- European folk art as a rule is utilitarian in purpose and serves the needs of a broad community.

- These parameters give the artists little room to express their own personalities.

In the United States, there were no art academies until the late 19th century, nor were there aristocrats or peasants. America's "class" system was more egalitarian and less rigid than Europe's. And while some

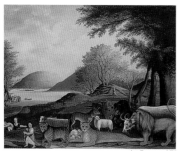

Edward Hicks
Peaceable Kingdom
1849. Oil on canvas
24 x 30 ¹⁄₄" (61 x 76.8 cm)

Americans did go overseas to study art, many American artists taught one another or they taught themselves, often by copying engravings. As a result, the United States had a far richer, more individualistic tradition of folk art than did Europe. Self-taught painters such as the Quaker preacher **Edward Hicks** (1780–1849) rank among the greatest American artists of the 19th century.

"Term" warfare

Some scholars maintain that in order for art to be considered truly *folk* art, it must conform to the European standard. By this definition, American folk art would be limited to functional objects like weather vanes and quilts. According to the purists, folk art died toward the end of the 19th century, when industrial manufacturing replaced handmade crafts in the production of items for domestic and commercial use. This traditionalist approach to folk art excludes all the paintings made by self-taught artists before the turn of the 20th century, as well as just about everything made thereafter.

To counter the traditionalists, scholars have come up with the alternative terms *Naïve, Primitive,* and *Outsider* to describe self-taught painters of the 20th century. The

problem with these terms, however, is that they suggest that the artist suffers from some kind of personality defect—that he or she is ignorant, crude, or just "out of it." African-American artists, in particular, have objected to being classified as "outsiders," because they feel this term validates a mainstream, white perspective.

A Talent is born

Anna Mary Robertson was born on September 7, 1860 (a Virgo!), on a farm in Washington County, New York, to parents who were of Scotch and Irish ancestry, **Russell King Robertson** (1820–1909) and **Mary Shannahan Robertson** (1840–1909). Much of what we know about her life is described in her wonderfully colorful 1952 autobiography, *My Life's History*.

Anna Mary spent the first 12 years of her life on the farm with her parents and brothers and sisters. It was a happy time, free from care and worry, during which she helped her mother by "rocking sister's cradle, taking sewing lessons from mother, sporting with my brothers, making rafts to float over the mill pond, roaming the wild woods, gathering flowers, and building air castles."

At the time of Anna Mary's birth, **Abraham Lincoln** (1809–1865) was president and the country was engaged in the Civil War (1861–65). Since there were no automobiles or airplanes, people traveled by train or by horse and buggy, and it could take a whole day to go a few miles.

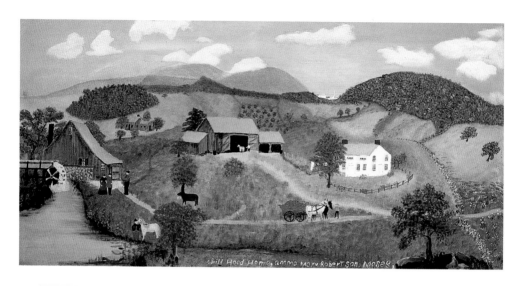

The Childhood Home of Anna Mary Robertson Moses. 1942
14 x 28"
(35.5 x 71 cm)
Kallir 160

There were newspapers, but no telephones, and neighbors chatted about the latest news when they gathered once a week for church services. There were no supermarkets or shopping malls—not even department stores outside of the big cities. Farms like that of Anna Mary's family were largely self-sufficient.

This early period in her life was radically different from the post–World War II world that would later welcome Grandma Moses as its favorite artist. Many of Moses's paintings were inspired by her childhood memories of life in the country, with its customs and rituals

and scenes of people interacting with each other and with nature. Her work allowed a war-weary public to travel back in time to a land that knew nothing of the stresses of modern life.

Creator of *Lambscapes*

As a little girl, Anna Mary had little time for art or for pursuits considered frivolous by adults faced with eking out a living from the land. Her father owned a flax mill and a farm in the small community of Greenwich in upstate New York, about 65 miles northwest of Bennington, Vermont. From an early age, Anna Mary and her siblings were taught the skills needed to survive on a farm. Routine schooling was a luxury often dispensed with. Sewing, washing, making soap, and cooking were the daily tasks that a girl of Anna Mary's social station had to master. But sometimes her father brought Anna Mary and her brothers some chalk and paper as a treat. While it cost the same as penny candy, it lasted longer. The boys used it to draw steam engines and animals, but already Anna Mary was obsessed with what she then called *lambscapes*.

Whereas her five brothers could help their father at the

Anna Mary Robertson (later Grandma Moses) at the age of four. 1864

OPPOSITE
Joy Ride.
1953
18 x 24"
(45.7 x 61 cm)
Kallir 1079

mill and on the farm, Anna Mary and her four sisters, though useful around the house, were seen to be something of a burden. At the age of 12, she went to work as a "hired girl" on a neighboring farm, helping a wealthier family with the household chores.

Childhood events pop up everywhere in Grandma Moses's paintings, and while few of her works are directly autobiographical, some observers have tried to identify the painted characters with specific people in her life. On occasion, perhaps to tweak inquisitive reporters, Moses would claim that she had included herself in various works, such as *Joy Ride*, where she figures as the woman in the lavender dress who stands in the doorway. At other times, however, she tended to contradict such statements. Paintings such as *Joy Ride* are probably based on generalized rather than specific memories.

Sound Byte:
"Father would hitch up the horses to the old big red sleigh and break out all of the roads, as we lived back in the fields, probably half a mile from the main road, and father had to keep the road open. He would drive up to the kitchen door, and we would all climb in the sleigh on a lot of straw and blankets, and away we would go, out to the main road, then on through the woods; and oh! that was grand to drive under the hemlocks and have the snow fall on us! Then back home and around the barn, back to the house. Oh, those happy days!"
—GRANDMA MOSES, *My Life's History*, 1952

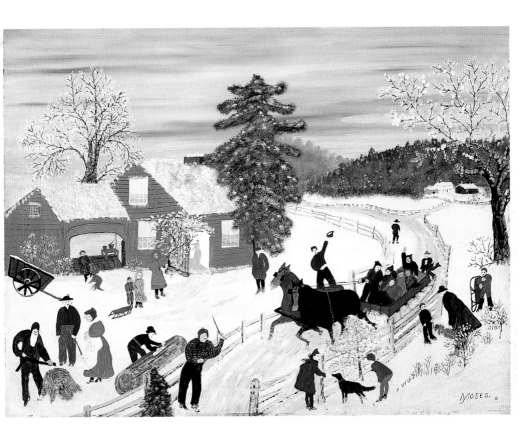

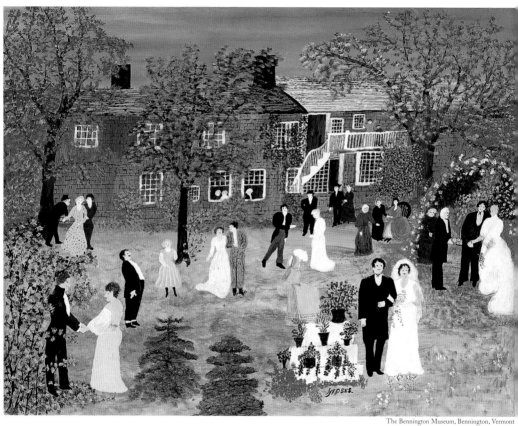

Married Life

Anna Mary remained a hired girl on various farms for the next 15 years until, at the age of 27, she met a farm hand, **Thomas Salmon Moses** (1861–1927), whom she married in 1887. Thomas had heard that the Reconstruction-era South was a land of opportunity for Yankees such as himself and, within hours of their wedding, the couple was on a train headed for North Carolina, where Thomas had secured a job managing a horse ranch. However, he and his bride never made it beyond Staunton, Virginia, where they stopped for the night and were persuaded to take over as tenants on a local farm.

The young Mrs. Moses fell in love with the beautiful Shenandoah Valley and would forever consider her chilly New York State home (albeit mountainous) a "swamp." Life was not always easy, though. Anna Mary, who believed in pulling her weight, bought a cow with her own savings and supplemented the family income by churning butter. Later, when times were tough, she would make and sell potato chips. Still, the family prospered and by the turn of the 20th century had earned enough to buy their own farm.

Although many people think of apples as a New England commodity, *Apple Butter Making* is actually among the handful of paintings based on Moses's Virginia memories. The house in the picture is the Dudley Place, one of several farms the Moses family occupied as tenants during

OPPOSITE
A Country Wedding
1951. 17 x 22"
(43.2 x 55.7 cm)
Kallir 968

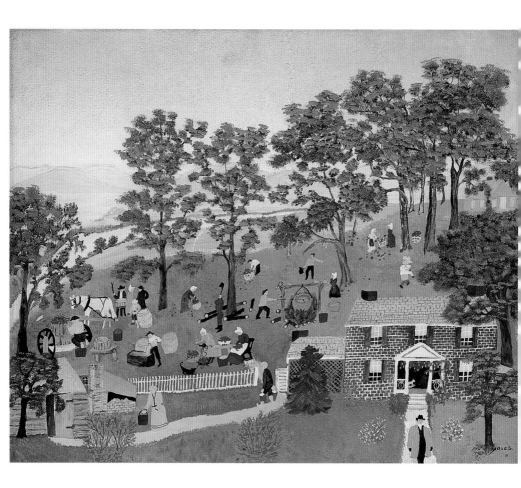

their years in the South. Late summer was apple-butter-making time. For Moses, apple butter was considered "a necessity."

Sound Byte:

"To make apple butter, you take two barrels of sweet cider (you grind the apples and make sweet cider first), then you put them in a big brass kettle over a fire out in the orchard and start it to boiling. You want three barrels of quartered apples, or snits, as they called them, with cores taken out, and then you commence to feed those in, and stirring and keeping that stirrer going. Women folks would keep that going, feeding in all the apples until evening. Then the young folks would come in to start stirring. They'd have two—a boy and a girl—to take hold of the handle. They'd have a regular frolic all night out in the orchard."

—GRANDMA MOSES, *My Life's History*, 1952

Birth of a mother

During their time in Virginia, Anna Mary bore ten children, only five of whom survived infancy. Always something of a matriarch, she became known to her neighbors as "Mother Moses."

The young mother would have been happy to spend the rest of her life in Virginia, but Thomas was homesick. In 1905, he persuaded his wife

OPPOSITE
Apple Butter Making
1947
19 ¼ x 23 ¼"
(48.9 x 59.17 cm)
Kallir 654

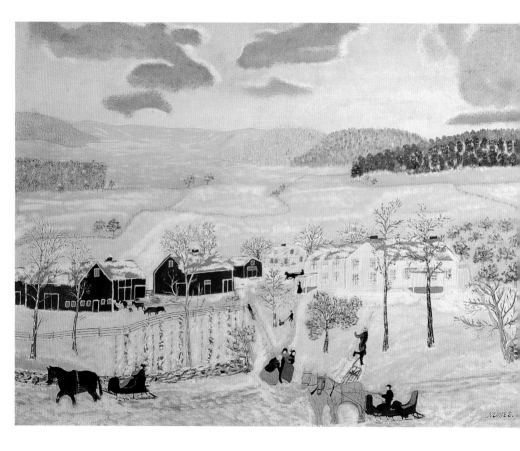

to return north. Upon arrival in her home state, Anna Mary observed that nothing seemed to have changed since they had left: "The gates are hanging on one hinge since I went away." She and Thomas bought a farm in Eagle Bridge, not far from her birthplace, and named it Mount Nebo—after the mountain where the biblical Moses had disappeared.

Fast-forward: The couple settled in and, for the most part, led a typical country life, with family get-togethers, local events, and daily chores. As a pastime, Moses dabbled with paint, but expressed no ambition for a career as an artist. Her earliest known painting, *Fireboard* (see page 20), dates to 1918, when she was 58. Apparently, while repapering the parlor, she ran out of wallpaper and decided to paint her own landscape on the board that is customarily used to seal off the fireplace in the summer— hence, the painting's name. She painted over the old wallpaper, which was later removed from the board.

Fireboard looks like the paintings of some 19th-century folk artists whose works Moses may have seen as a child. In a more general sense, *Fireboard* landscape, with its loosely brushed foliage and relatively somber palette, vaguely resembles the paintings of the Hudson

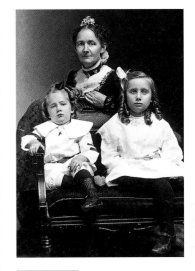

ABOVE
Anna Mary Moses with two of her youngest children, Hugh and Anna. c. 1904

OPPOSITE
Mount Nebo in Winter
1943. 20 ¹/₂ x 26 ¹/₂"
(57.07 x 67.31 cm)
Kallir 275

River School, whose influence would have been felt throughout New York State when Moses was growing up. Note that the colors are much duller and more muted than those typical of Grandma Moses's later work.

> **FYI: Hudson River School of Art**—During the mid-19th century, a period of Romanticism in art and literature, the painter **Thomas Cole** (1801–1848) founded the Hudson River School—also known as the American Landscape Movement—the first "school" of painting in the United States, which lasted from 1825 to 1870. Cole achieved great success and won the attention of important patrons. His nationalistic and religious views of nature contributed greatly to the emergence of landscape painting as a respected movement in American art. Other Hudson River artists included **Albert Bierstadt** (1830–1902), **Asher Brown Durand** (1796–1886), **Frederic Edwin Church** (1826–1900), and **Sanford Gifford** (1823–1880). They believed that nature was a direct manifestation of God, and in panoramic compositions that reflected moral messages, the Hudson River artists used extreme details of nature to show human emotions.

Another early work

Autumn in the Berkshires, a work that is difficult to date, may have been done as early as the 1920s. It is one of Moses's first independent attempts to copy and adapt a common 19th-century chromolithograph

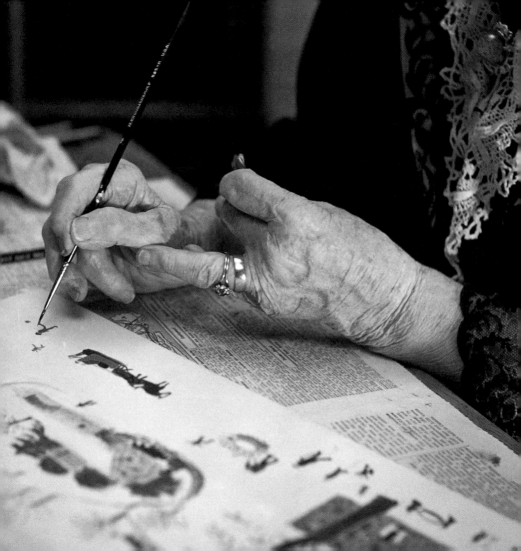

subject (see BACKTRACK on page 46). Like much of the artist's earliest work, *Autumn in the Berkshires* reveals her ingrained sense of frugality and practicality. The painting is executed on a scrap of canvas that was left over after making a new cover for the threshing machine on the Moses farm.

Suddenly, a widow

In 1927, Thomas Moses died of a heart attack at their farm, Mount Nebo. Moses was not one to sit idle after her husband's death. Though

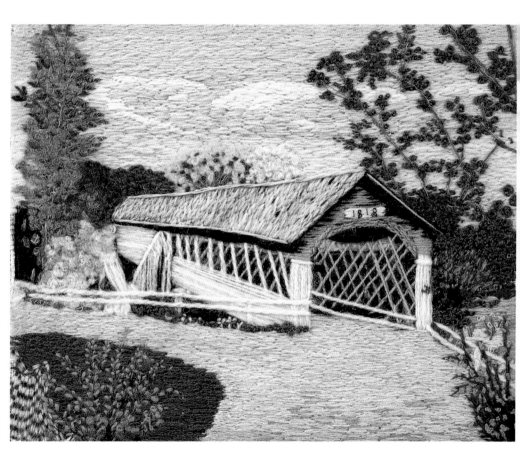

all the Moses children were grown, there was still plenty of work to be done on the farm. In 1932, Moses went to Bennington to take care of her daughter **Anna**, who was suffering from tuberculosis.

For better or for *worst*

Moses's first sustained encounter with image making involved not paint but *worsted* yarn (i.e., a smooth, compact yarn made from long wool fibers). Sewing and embroidery had been an integral part of her training as a child, in the days before store-bought clothes were readily available. Whereas painting may have seemed frivolous, embroidery had a practical aspect.

Challenged by her daughter

One day, Anna showed her mother a picture, embroidered in yarn, and challenged her to duplicate it. So Mother Moses began stitching what she called *worsted* pictures and started giving them away to anyone who would have them. But unlike paint, embroidery yarn could not be mixed and blended. In order to achieve subtle tonal effects, one had to place strands of differing colors side-by-side. This technique taught Moses to break colors down into their component hues, much as the French Impressionist painters had done in the 1860s and 1870s. In fact, it's her pseudo-Impressionistic method of dabbing paint that gives Moses's landscape effects such richness and subtlety.

After creating a number of worsted pictures, Moses complained that

OPPOSITE
The Covered Bridge. c. 1939
Worsted wool
7 1/2 x 9 1/2"
(19 x 24.1 cm)
Kallir 13W

arthritis made it hard for her to hold a needle. Her sister **Celestia** suggested she try painting instead, even though Moses had already painted from time to time in the past. It was in this casual manner that the career of Grandma Moses began.

Sound Byte:

"If I didn't start painting, I would have raised chickens. I could still do it now. I would never sit back in a rocking chair, waiting for someone to help me. I have often said, before I would call for help from outsiders, I would rent a room in the city some place and give pancake suppers."

—GRANDMA MOSES, *My Life's History*, 1952

Back to Eagle Bridge

After the death of her daughter in 1933 from tuberculosis, Moses stayed in Bennington to look after her grandchildren until Anna's husband remarried. Then, she returned to Eagle Bridge and started painting in earnest. She later recalled that her husband had admired her artwork, and she liked to think his spirit was watching over her, offering approval if not guidance.

The "Discovery" of Grandma Moses

Soon Moses had more paintings than she could realistically make use

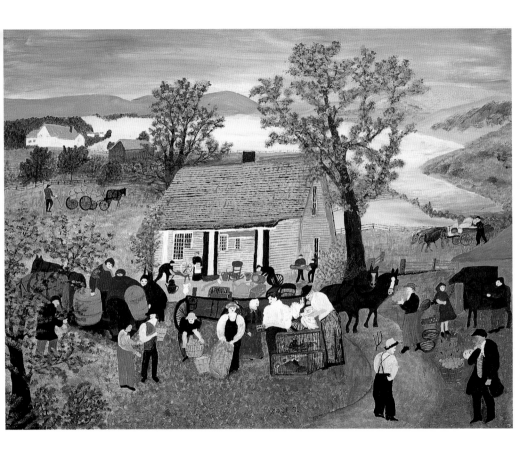

Seiji Togo Memorial, Yasuda Kasai Museum of Art, Tokyo

of. She sent some to the Cambridge country fair, along with her canned fruits and jams. "I won a prize for my fruit and jam," she sardonically noted later, "but none for my pictures." Here Moses's painting career might have foundered. As much as she loved art, Moses was above all a sensible woman, and to pursue art for art's sake alone would, by and by, have come to seem a petty indulgence. But in 1936, **Caroline Thomas**, the widow of the druggist in the neighboring village of Hoosick Falls, invited Moses to contribute to a women's exchange she was organizing at the drugstore.

Here's looking at you, Grandma!

Moses's paintings sat in the drugstore window for several years, gathering dust next to crafts and other objects created by local homemakers. Then, during Easter week of 1938, a New York City collector named **Louis J. Caldor** (d. 1966) passed through town. Caldor traveled regularly in connection with his job as an engineer for the New York City water department, and he was in the habit of seeking out local artistic "finds." The paintings in the drugstore window caught his eye and he asked to see more. The collector ended up buying the whole lot. He also got the artist's name and address and set off to meet her in person.

Dangling a carrot

Moses's family thought Caldor was crazy when he told the budding

painter that he would make her famous. And indeed, for the next few years, it seemed the family was right. Caldor brought his trove of Moses paintings to New York City and doggedly made the rounds of museums and galleries. Even those who admired the work lost interest when they heard the artist's age. Turning 78 in 1938, Moses hardly seemed worth the effort and expense involved in mounting an exhibition and building a career. Her life expectancy was such that most dealers thought they would never reap a profit on their initial investment. Still, Caldor persisted, and in 1939 he had his first limited success. He showed some of Moses's work to the dealer/collector **Sidney Janis** (1896–1989), who selected three of her paintings for inclusion in a private viewing at The Museum of Modern Art (MoMA). The exhibition had no immediate impact, since it was open only to museum members, but it was an indication of exciting times ahead.

The "Sophisticates" discover the *Naïves*

Throughout history, there have always been artists who painted without the benefit of formal training, purely for themselves or their families, or for the local community. During the time when the standards of the European art academies ruled, no one paid much attention to the work of these self-taught artists. However, starting with the French Impressionists, artists began to break away from the conservative dictates of the academies and from the constricting requirements of academic realism. In the early 20th century, avant-garde artists such as **Pablo Picasso** (1881–1973)

and **Vasily Kandinsky** (1866–1944) decided that they could, in fact, learn from the example of self-taught artists, whose work they considered purer and more original than that of trained painters.

Sound Byte:
"Even if you do not do it for anyone else, I will be only too happy if you keep on painting just for me alone, for I always feel that sooner or later I will be able to publicly justify my opinion of you and bring you some measure of respect and recognition for your efforts."
—LOUIS CALDOR, letter to Grandma Moses, 1939

The first *Naïve* artist to be discovered by the turn-of-the century avant-garde crowd was **Henri Rousseau** (1844–1910), a French customs collector who was hailed for the apparent guilelessness or "innocence" of both his paintings and his personality.

The passion for the *Naïve* spread quickly across Europe and—after World War I—to America. In 1927, the quest for an "American Rousseau" bore fruit when an ordinary house painter, **John Kane** (1860–1934), was admitted to the prestigious Carnegie International exhibition. Kane's sudden good fortune paved the way for the emergence of kindred talents. By 1938, MoMA had enough works for a bold and exciting new show, "Masters of Popular Painting," which included—in addition to works by Kane and Rousseau—those of a

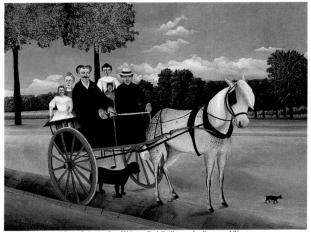

Henri Rousseau
The Cart of Père Juniet
1908
Oil on canvas
38 ¹⁄₄ x 50 ³⁄₄"
(97.1 x 127.6 cm)

Musée de l'Orangerie, Paris; Collection Jean Walter et Paul Guillaume. Art Resource, NY

recent discovery, the brilliant African-American painter **Horace Pippin** (1888–1946). The museum's founding director, **Alfred Barr** (1902–1981), was bold enough to identify self-taught art as one of the principal elements of modernism.

Sound Byte:

"The academy is the surest means of ruining the force of the child. An academically educated person of average talent distinguishes himself by having learned the practical-purposeful and by having lost the ability to hear the inner resonance. Such a person will deliver a 'correct' drawing which is dead. If a person who has not acquired schooling—and thus is free of objective artistic knowledge—paints something, the result will never be an empty pretense."

—VASILY KANDINSKY, artist, *Der blaue Reiter Almanac*, 1912

"What a Farmwife painted"

Finally, in 1940, Caldor stopped at the Galerie St. Etienne in Manhattan. Recently founded by **Otto Kallir** (1894–1978), a Viennese émigré, the Galerie St. Etienne specialized in modern Austrian masters such as **Gustav Klimt** (1862–1918), **Oskar Kokoschka** (1886–1980), and **Egon Schiele** (1890–1918). But Kallir, like many of the pioneers who championed modernism in the pivotal decades between the two world wars, was also interested in the work of self-taught painters. He immediately recognized Moses's talent and, undeterred by the artist's advanced years, agreed to give her an exhibition.

The Big Apple beckons

Anna Mary Robertson Moses made her public debut at the Galerie St. Etienne in October 1940 in an exhibition that Kallir entitled "What a Farmwife Painted." He created this curious title because it seemed unlikely that an unknown artist's name would attract much attention. The St. Etienne exhibition, though well publicized and well attended, was only a modest success. The artist was not yet officially known as "Grandma Moses." Only three paintings, priced at between $20 and $200, were sold.

One of the works included in this exhibition was *The First Automobile*. The painting reflected Moses's interest in subjects that combined themes from popular prints with memories of events that she had personally experienced.

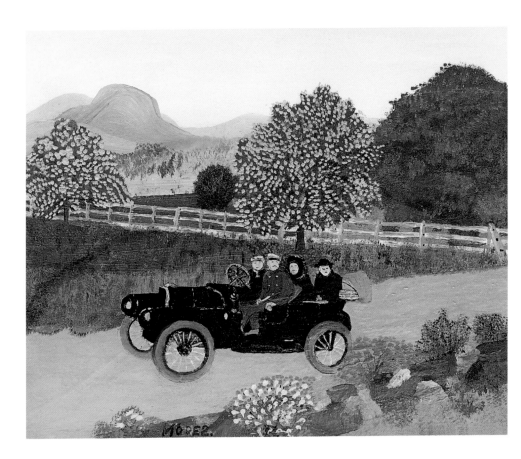

The composition of *The First Automobile* is reminiscent of an approach often used in conventional landscape illustration. Traditionally, landscapists have tended to concentrate on either foreground or background, but seldom both at once. When the focus is on anecdotal detail, as in *The First Automobile*, the surrounding landscape is reduced to little more than a backdrop. On the other hand, if you compare *The First Automobile* with a slightly later version of the same subject, *The Old Automobile* (see page 36), you can see how Moses eventually expanded her approach to include both foreground *and* background detail—one of the unique hallmarks of the "Grandma Moses style."

Revving up at Gimbels

What really got Moses's career rolling was a Thanksgiving Festival organized by Gimbels Department Store in 1940, shortly after the St. Etienne show had closed. The retailer assembled a number of paintings at thestore

ABOVE
Grandma Moses and Carolyn Thomas at Gimbels Department Store, New York, 1940

OPPOSITE
The First Automobile
1939 or earlier. 9 ³/₄ x 11 ¹/₂"
(23.5 x 29.2 cm) Kallir 6

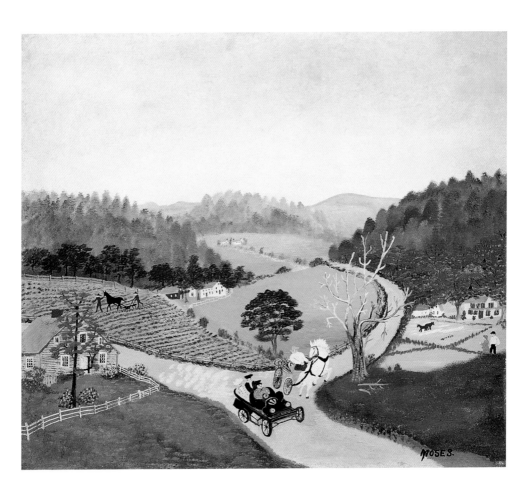

and invited Moses to come to New York for the show's opening. In her little black hat and lace-collared dress, accompanied by the proprietary Caroline Thomas, Moses (perhaps remembering her experiences at the country fair) delivered a forthright public address on her jams and preserved fruits. The hard-boiled New York press corps was delighted and the legend of Grandma Moses was born.

The name "Grandma Moses"

Moses had been a matriarch long before she was discovered by the New York news media. She had already been known as "Mother Moses" for a number of years, and, as she grew older, began to be called "Grandma Moses." A few months after the artist's debut at the Galerie St. Etienne, a journalist, interviewing Anna Mary's friends in Eagle Bridge, learned that the locals knew her by this nickname. From that moment on, the name "Grandma Moses" stuck.

ABOVE
Detail of *The Old Automobile*

OPPOSITE
The Old Automobile
1944. 18 ³/₄ x 21 ¹/₂"
(46.35 x 54.61 cm)
Kallir 442

OPPOSITE
Grandma Moses
at her painting
table. 1952
Photograph by
Ifor Thomas

Tricks of her trade

Grandma Moses had probably never set foot in an art supply store when she first began painting. She used whatever materials were at hand: old bits of cardboard, scraps of leftover cloth, and house paint. Lacking fine brushes, she used pins or matches to paint delicate details. Louis Caldor sent Moses her first regulation artist's painting kit, and as her career progressed, Moses obtained steady access to professional supplies. Still, she had some unusual requests: Otto Kallir's partner, **Hildegard Bachert** (b. 1921), had a standing order to bring glitter whenever she visited, since Moses liked to sprinkle this on her snow scenes to make them sparkle. Although Moses used canvas for some of her largest works, she preferred to paint on a harder, less flexible material. She liked the support of a rigid board, so she settled on pressed wood— a manmade composition board often sold under the brand name Masonite™. The ever-practical Moses created almost all of her mature work on pressed wood, since she believed it would last longer than canvas.

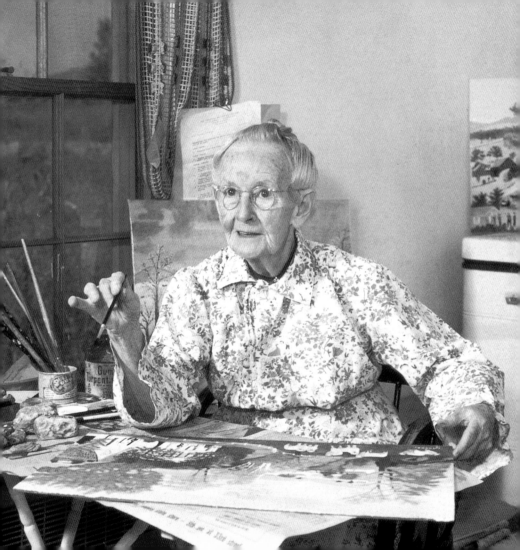

"Before I start painting, I get a frame, then I saw my Masonite board to fit the frame. (I always thought it a good idea to build the sty before getting the pig....) Then I go over the board with linseed oil, then with three coats of flat white paint to cover up the darkness of the board."

—GRANDMA MOSES, *"How I Paint,"* 1952

FYI: The Moses "swipe file"—Throughout history, self-taught artists have learned to paint by copying whatever visual source material happens to be available to them. These sources often include prints and popular illustrations. Grandma Moses loved old prints, like those published by Currier & Ives in the late 19th century, since they recalled the bygone days of her childhood and early adulthood. Many of her first paintings and embroideries were copied from such prints. But soon, Moses became frustrated by rote copying. She wanted to make the subjects *hers*, in terms of both content and composition. So she began to experiment with her printed sources, incorporating those aspects of the composition that interested her and leaving out the rest. Soon, she learned that she could achieve a broader variety of effects by combining elements from several printed sources. Grandma Moses continuously collected magazine and newspaper clippings, and by the time she died, her "swipe file" consisted of hundreds of little cutout images depicting such stock items

as houses, barns, farm animals, and farmers. Her compositional process involved selecting the clippings best suited to the subject at hand and moving them around on the pressed-wood panel that was her preferred support. Once she had a pleasing arrangement, she then traced the outlines of the figures onto the panel and filled in the surrounding landscape based on memory and observation.

Getting bigger

Moses's earliest paintings, possibly conditioned by the format of the greeting cards and prints that had inspired them, were quite small. However, from the onset of her professional career, people encouraged her to paint bigger pictures. With growing confidence and a surer technique, the artist happily complied, and her mature work ranged from 12 x 16" (34 x 40.7 cm) to 24 x 30" (61 x 68.6 cm). Moses also executed a dozen or more oversized works, such as *Country Fair* (see page 44).

The canvases that she used for these oversized works were too large for the "tip-up" table on which she customarily painted, and instead they had to be laid flat on her bed. Moses was not entirely pleased with the final works—which she called "really too large to be pretty"—but in fact the push to bigger sizes literally forced her to expand her horizons. In these oversized paintings, she exploited the scale to the maximum,

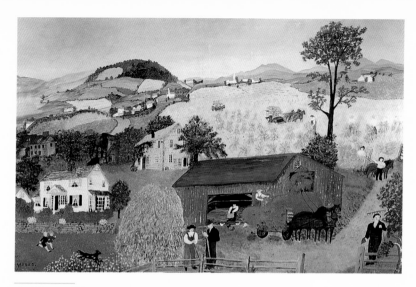

In Harvest Time
1945. 18 x 28"
(45.72 x 71.12 cm)
Kallir 537

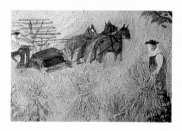

Detail of *In Harvest Time*

Newspaper clipping of an illustration of harvest, with Moses's pencil outlining around the horses, farm hands, and bales of hay. (This image was a source for *In Harvest Time*.)

What? If any one farm activity can be said to sum up Moses's philosophy on life in the country, it was the process of sowing and harvesting—i.e., the annual payoff for productive labor.

How? As Grandma Moses gained in artistic confidence, she ventured into more complex and original compositions, even though she continued to find inspiration in her great trove of printed source material. *In Harvest Time* is a good example of the process by which Grandma Moses incorporated printed sources into her mature work. In arranging the composition, she chose a number of clippings from her "swipe file." She would select the appropriate clippings and arrange them on the pressed-wood (i.e., Masonite™) panel that was her preferred support. After arranging the clippings the way she wanted them, she traced their outlines onto the board, possibly with carbon paper. If you compare one of her clippings to Moses's final painted work, you'll see that the artist copied only the broadest contours. She was interested in reducing her vignettes to their abstract essentials rather than slavishly duplicating the image from the clipping. Though Moses had never formally studied *perspective*, she knew in a vague way that objects in the foreground should be larger than those in the background. The strange discrepancies in scale that one sometimes finds in her work probably result from the clippings at hand when the composition was being planned. In the process of tracing, she removed almost all the illustrative detail of the original clippings, and thus transformed them into more abstract images containing fewer references to specific people or places. Moses then used landscape elements, based on her acute observation of nature, to give life to these abstract elements. By converting fairly prosaic illustrations into abstract distillations of form, Moses populated her paintings with a cast of symbolic characters. With narrative detail reduced to a bare minimum, her figures cannot evoke the past in any specific, documentary manner. Instead, they become symbols with which everyone could identify. Moses created a **paper-doll world** peopled not by real creatures but by *symbols* of real creatures. The imagination involved when viewing her works is similar to that found in child's play. Her viewers are invited to finish the story, cued by details of place and occupation. The sphere of action is thus removed from a personal to a universal plane.

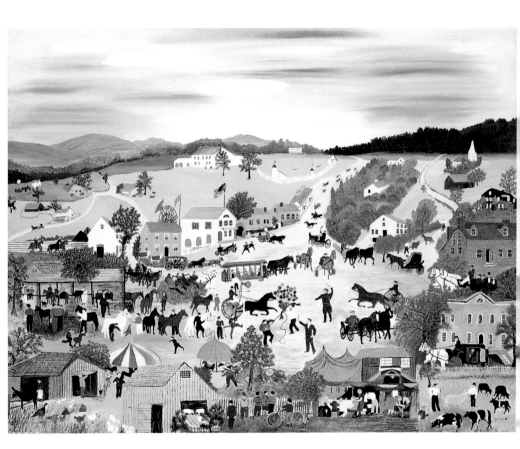

creating a richer and more complex composition than would have been possible on a smaller canvas.

Country fairs were important social events in the days before modern technology facilitated ready travel and communication. Often, these annual gatherings were the only times that all the members of a larger rural community would meet.

A favorite subject

Of all Moses's favorite subjects, "sugaring off" was the one she returned to most frequently. It was also one of the most beloved by her fans. Like other of her recurring motifs, the sugaring theme was influenced by both popular illustration and lived experience. The process of tapping the maple trees in late winter to release the sap that is used to make maple syrup and candy was familiar to the artist from earliest childhood.

"Sugaring off" also figured in a well-known Currier & Ives lithograph (see next page). While Moses never executed an identical copy of the Currier & Ives composition, she included a miniature version in the right-hand side of *Sugaring Off in Maple Orchard*. However, even in this relatively early rendition of the subject, Moses added to her basic source, appending numerous ancillary figures (many probably copied from magazine clippings). Most significant, however, is her original evocation of the icy, overcast winter landscape, which gives the scene an atmospheric depth that is totally lacking in any of its sources.

OPPOSITE
Country Fair
1950
Oil on canvas
35 x 45"
(88.9 x 114.3 cm)
Kallir 91

The invention of **lithography** in the 19th century revolutionized printing. (Note: lithography is the process of printing from a chemically treated plane surface, such as smooth stone or metal printing plates, onto an ink-receptive surface such as paper.) For the first time, lithography made it possible to print multicolored images in large sizes and quantities. As a result, these images became available to millions of people who could not afford original paintings. These **chromolithographs** (as the colored prints were called) were often gaudy and lacking in pictorial subtlety, but they proved immensely popular. One of the most successful chromolithograph publishers was the New York firm of Currier & Ives. Long after Currier & Ives had ceased production, its famous homespun images continued to proliferate in magazines, wall calendars, and so forth.

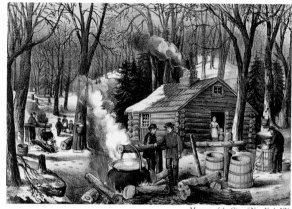

Museum of the City of New York, NY

Currier & Ives. *Maple Sugaring: Early Spring in the Northern Woods*. c. 1872. Lithograph

A 1943 version of *Sugaring Off*, which appears on page 48, shows how Moses's style had developed in three short years. The artist had gained formidable mastery of her medium. She was capable of rendering details with pristine clarity and of handling extremely complex compositions. *Sugaring Off* is notable for its vast assortment of disparate activities, arrayed in a preternaturally broad landscape. This quiltlike opening up of the landscape into an almost square panoply of detail is one of the hallmarks of the Grandma Moses style.

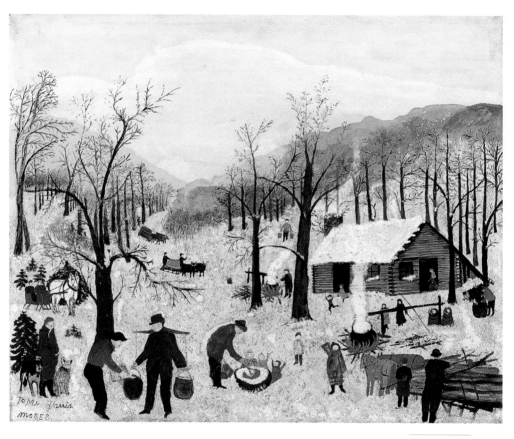

*Sugaring Off in
Maple Orchard*
1940. 18 ⅛ x 24 ⅛"
(46.17 x 61.42 cm)
Kallir 56

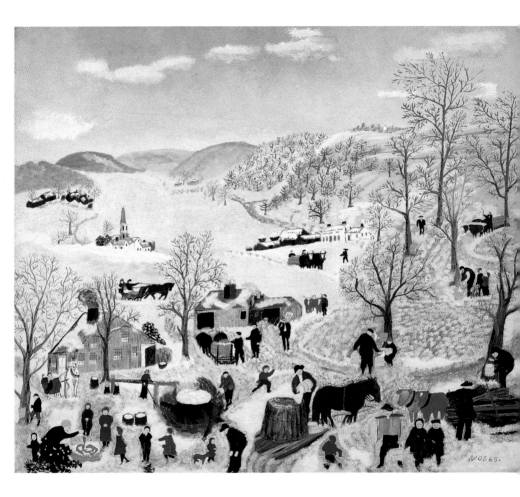

Gaining *perspective*: revelation in a hubcap

For a number of years, Grandma Moses had struggled to find a way of combining close-up details with the sweeping landscape panoramas she loved. Oddly, she discovered the solution to her problem in the hubcap of a car. In the convex, mirrored surface common to hubcaps in the 1940s, Moses saw a reflection of the entire valley below her farm, spread out and enlarged as in a fish-eye camera lens. This revelation prompted her to rethink the horizontal dimension of her pictures in favor of a deeper, almost square, format.

OPPOSITE
Sugaring Off
1943. 23 x 27"
(56.4 x 66.2 cm)
Kallir 276

A "breakthrough" painting

Black Horses, painted two years after Moses's debut exhibition at the

49

Galerie St. Etienne, shows remarkable progress in its originality of style and composition. The work depicts the local landscape as a kind of patchwork quilt, granting equal attention to the background, middle ground, and foreground. Exquisitely sensitive to the shifting hues of nature, *Black Horses* is an accurate evocation of the season as well as of the place.

OPPOSITE
Black Horses
1942. 20 x 24"
(50.8 x 60.96 cm)
Kallir 181

Warmth and humor

The title *Early Springtime on the Farm* reflects Moses's dry Yankee humor. While the calendar may say it is spring, there is still plenty of snow on the ground up north. But the ground has begun to thaw in the painting's foreground, where a flock of geese waddles along on fresh turf. Moses invariably recalled her childhood in such idyllic terms: "These were the damp snow days when we loved to go to the woods and look for the first bloom of the trailing arbutus, which sometimes bloomed beneath the snow, or gather the pussy willow. Those were the days of childhood."

Yet the artist's autobiography reveals a number of events that were far from blissful: the burning of her father's mill; storms so severe they almost wiped out the farm;

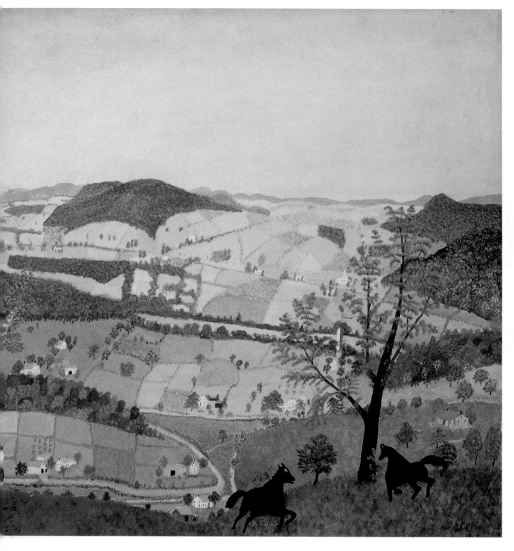

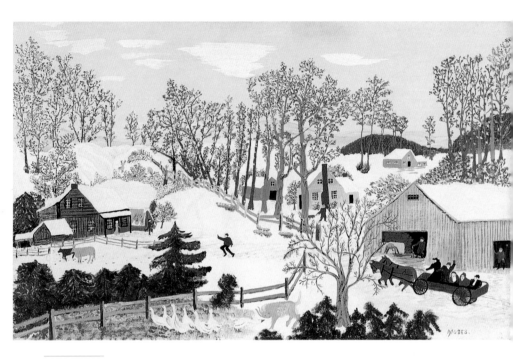

Early Springtime on the Farm
1945. 16 x 25 ³/₄"
(40.7 x 65.4 cm)
Kallir 500

and illnesses, today readily controllable, for which there was no cure at that time. Two of Moses's brothers and one sister did not make it to adulthood. The tranquillity in Moses's art comes not from denying unpleasant realities but from making peace with them and from linking the events of the past to the world as seen through her eyes.

Working the Angles

The subject of the *Checkered House* (see page 54) was a local legend. Situated along the Cambridge Turnpike, it was an inn where stage-coach drivers had changed horses as far back as the 18th century. During the American Revolution (1775–83), the inn had served as General Baum's headquarters and field hospital. Its checkerboard front made the house a distinctive landmark that was remembered long after it burned down in 1907. Moses painted a number of versions of the checkered house, in both winter and summer. To alter the composition, she tried to imagine the scene as if she were looking through a window. By shifting her viewpoint slightly, she could cause the elements to fall into place differently. "And that is how I worked the angles," she explained. Catching the turkey—part of the annual Thanksgiving ritual—was another theme that Moses painted numerous times. Though she often repeated subjects, no two compositions were ever alike.

For the first monograph on her works, *Grandma Moses, American Primitive* (edited by Otto Kallir in 1946, then reissued in 1947), the artist was asked to write a commentary on 40 of her favorite paintings. Of *Catching the Thanksgiving Turkey* (on page 55), she wrote (and notice her spelling): "Why do we think we must have turkey for thanksgiving. Just because our Forefathers did, they had it becaus turkeys were plenty-full, and they did not have other kinds of meat, now we have abundance of other kinds of luxuries. Poor Turkey, he has but one life to give to

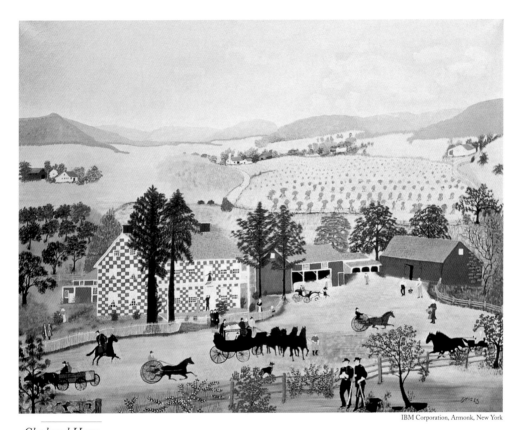

Checkered House
1943. 36 x 45"
(91.5 x 114.3 cm)
Kallir 317

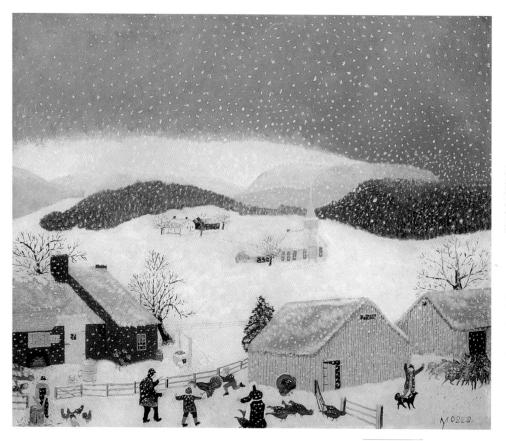

Catching the Thanksgiving Turkey. 1943. 18 1/2 x 24"
(47 x 61 cm)
Kallir 231

his country." The spelling and punctuation in Moses's text, which was printed in her handwriting, were not altered for publication. This caused the artist grave embarrassment, as did the book's title. When Moses's autobiography was published some years later, her spelling and grammar had been corrected and the word "primitive" was absent.

Sound Byte:

"My boys are so disgusted they threatened to bring suit if they could find out who wrote some of those articles that were in the papers. One of the neighbors asked if it was so, that I could not read or write, being a primitive."

—GRANDMA MOSES, writing in disgust to the collector
Louis Caldor in 1941

The Road to Fame

OPPOSITE
The McDonnell Farm. 1943
24 x 30"
(61 x 76 cm)
Kallir 313

Moses's talk at Gimbels in 1940 had brought a burst of publicity because she was something of a local celebrity. But her renown was confined to New York State, where she exhibited at a number of upstate venues and found herself besieged by vacationers seeking artistic souvenirs. For some years, Moses resisted signing a formal contract with Otto Kallir, since she felt capable of managing matters herself. But in 1944, frustrated by the seasonal nature of her tourist-oriented business and by the difficulty in collecting payment from some of her customers, she agreed to be represented exclusively by the Galerie St. Etienne and

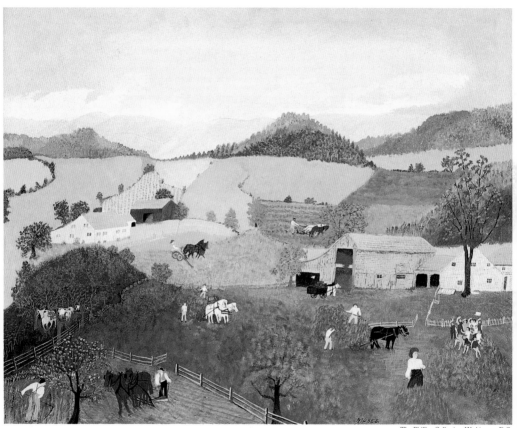

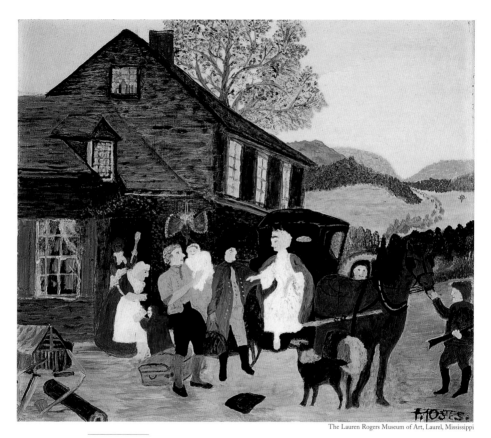

The Daughter's Homecoming
Early 1940s. 12 x 14"
(50.2 x 59.7 cm)
Kallir 1514a

Picnic
1945. 24 x 30"
(61 x 76 cm)
Kallir 484

by Ala Story, director of the American British Art Center, who had also become a steady buyer of Moses's work.

Kallir and Story immediately launched a series of traveling exhibitions that would bring Moses's work, over the next two decades, to more than 30 American states and ten European nations.

Influence of embroidery on the Grandma Moses Style

Moses's paint textures mimic embroidery. Her fence posts seem *stitched* into place and her blossoming trees appear to be rendered in little knots of thread. Moses usually established a series of textural gradations in her paintings, from flat expanses and isolated blocks of color to more intricate, multicolored configurations. She deliberately executed certain details in raised paint in order to set them off from the background. Many of Moses's paintings, when viewed up close, are actually composites of abstract forms. Unlike paint, embroidery yarn could not be mixed and blended. In *Hoosick Valley (From the Window)*, she set varied tones of green and yellow next to one another to evoke the interplay between parched meadows and verdant hills.

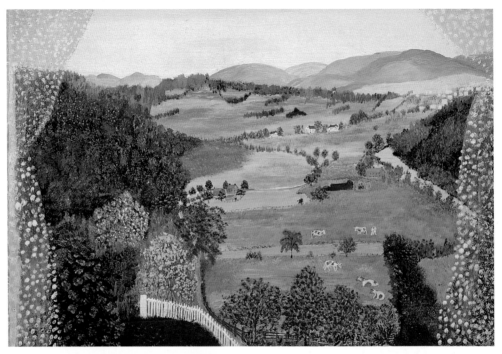

RIGHT
Signature of
Grandma Moses

OPPOSITE
*A Tramp on
Christmas Day*
1946. 16 x 9 ⁷/₈"
(40.64 x 25.01 cm)
Kallir 595

Memories of Christmas

Grandma Moses was closely associated with Christmas, in part because for many years Hallmark issued a best-selling line of Moses Christmas cards, but also because that holiday—with its combination of wintry cheer, evergreen trees, and joyful celebration—mirrors many of the artist's own favorite preoccupations. Like all her work, Moses's Christmas paintings were inspired by her own experiences as a little girl.

Sound Byte:
"Christmas morning.... I scrambled out of bed.... Oh! how good things smelled. The living room and parlor were all decorated with evergreens around the doors and windows; everywhere was hemlock, Mother's favorite evergreen. And the smell of hemlock and varnish has always been a favorite of mine ever since."

—GRANDMA MOSES

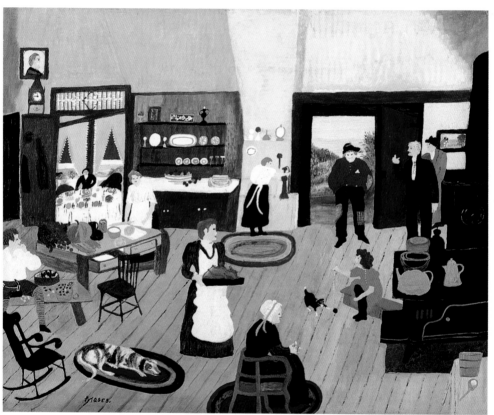

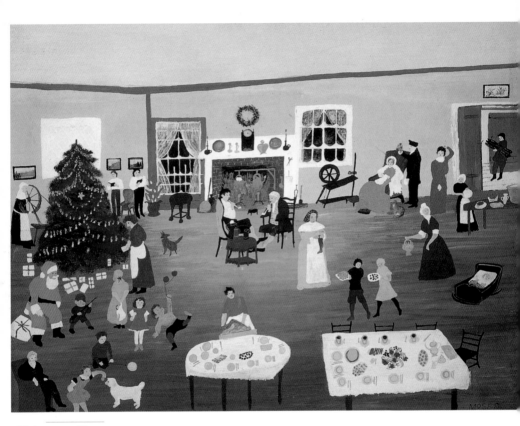

Christmas at Home
1946. 18 x 23"
(45.72 x 58.42 cm)
Kallir 586

Fast-forward: After Kallir signed his contract with Moses, the events that established her as a national and international celebrity followed in quick succession:

- In 1946, Kallir edited the first monograph on the artist, *Grandma Moses, American Primitive,* and oversaw the licensing of the first Moses Christmas cards. Both projects proved so successful that the following year the book was reprinted and the license for greeting cards was awarded to Hallmark.

- In 1949, Moses traveled to Washington to receive an award from President Truman, and, at an informal tea the following day, he played the piano for the artist.

- The next year, a documentary film on the life of Grandma Moses, narrated by Archibald MacLeish, was nominated for an Academy Award.

- Her autobiography, *My Life's History*, was published in 1952.

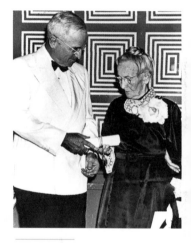

Grandma Moses receiving the Women's National Press Club Award from President Harry S Truman. May 14, 1949 (Note: There is no period after the "S" in Harry S Truman. The "S" is not an abbreviation, but a middle *name* he gave himself in order to make "Harry Truman" sound more serious.)

Alternatives to academic perspective

While Moses's way of piecing together compositions was dictated partly by her sense of abstract design, the arrangements were always subordinated to the requirements of the landscape. As a substitute for academic *perspective* (which she had never learned), she employed not just a progressive scheme of diminishing sizes, but also a number of coloristic indicators of space. She was quick to note such qualities as the pale blue of distant hills, or the tonal gradations of the sky. She translated phenomena observed in nature into veils of color and layers of pigment.

The Spring in Evening is notable for the way in which Moses captured both the time of year and the time of day. The rawness of the freshly plowed earth, the new growth on the hillside, and the soft pink of the sunset are all recorded with a sure feeling for color and a striking realism. Variations in the physical and tonal density of the paint create

Two details of
*The Spring in
Evening*

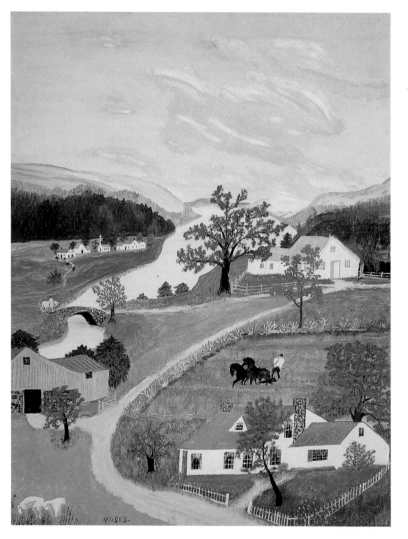

The Spring in Evening
1947. 27 x 21"
(68.6 x 53.3 cm)
Kallir 706

a series of transitions between the artist's anecdotal vignettes and the more complex hues of the landscape.

A feeling for nature...and oak buckets!

Like many of Mose's favorite subjects, *The Old Oaken Bucket* combines local lore and personal experience. In 1877, young Anna Mary worked as a hired girl for an elderly woman, Mrs. David Burch, who told Anna Mary that the well on her farm was the original well that had inspired the famous song "The Old Oaken Bucket." Mrs. Burch explained that back in the 18th century, when her great-grandfather lived on the farm, his brother had fallen in love with one of the neighbor's daughters. Since the girl's parents opposed the relationship, the young man went off to sea, where he wrote the song commemorating the well where he and his girlfriend used to meet.

Sound Byte:

"When I paint, I study and study the outside lots of times. Often I get at a loss to know just what shade of green, and there are a hundred trees that each have three or four shades of green in them. I look at a tree and I see the limbs, and then the next part of the tree is a dark, black green, then I have got to make a little lighter green, and so on. And then on the outside, it'll either be a yellow green, or whitish green, that's the way the trees are shaded."

—GRANDMA MOSES, *My Life's History*, 1952

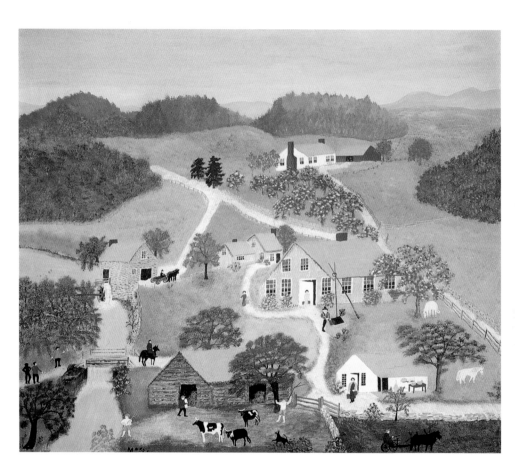

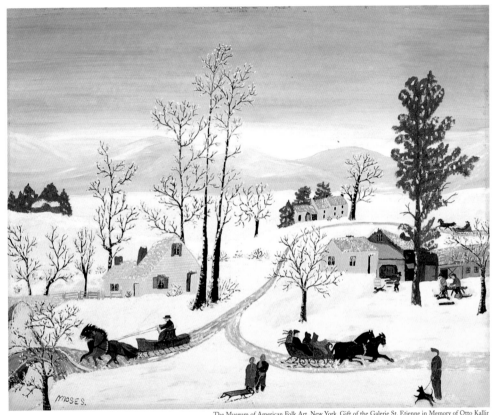

The Museum of American Folk Art, New York. Gift of the Galerie St. Etienne in Memory of Otto Kallir

The Dividing of the Ways. 1947
16 x 20"
(40.7 x 50.8 cm)
Kallir 701

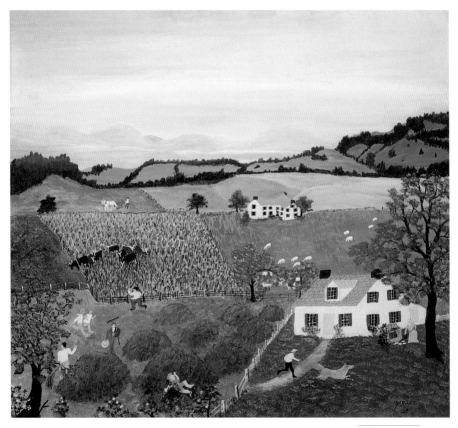

Little Boy Blue
1947. 20$^{1}/_{2}$ x 23"
(52.07 x 58.42 cm)
Kallir 660

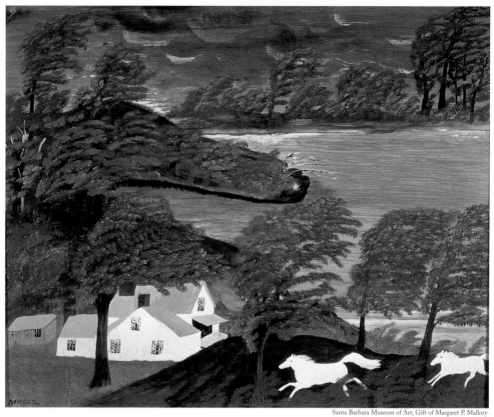

Stormy weather

If you know Grandma Moses's paintings only from reproductions, you might not notice how accurately she depicted nature. In fact, it was her ability to precisely evoke the rural landscape that brought her paintings to life and that, to a large extent, has accounted for their enduring appeal. This aspect of Moses's achievement is most readily seen in her storm scenes where, of necessity, the various forces and colors of nature appear in exaggerated form. *A Storm is on the Waters Now* is one of her most dramatic pictures. Compared with *The Thunderstorm*, it is a simple composition. However, by focusing on the terror of the two white horses, Moses distilled and highlighted the impact of the raging torrent. A relatively limited palette further heightens the emotional effect.

The Colors of nature

The Thunderstorm illustrates how Grandma Moses managed to combine intensely evocative renditions of natural phenomena with dramatic anecdotal detail. There are several levels of action in this painting. Fierce storm clouds approach rapidly over the mountains, and in the distance the trees have already begun to whip wildly in the wind (see top detail, page 75). Moses's deployment of color to represent these events was extraordinarily acute: Notice that the parched yellows of a late summer meadow, the varied greens of the trees, and the shifting colors of the sky before the advancing torrent are all keenly observed.

OPPOSITE
A Storm is on the Waters Now
1947. 16 x 20 ¹/₂"
(40.64 x 52.07 cm)
Kallir 666

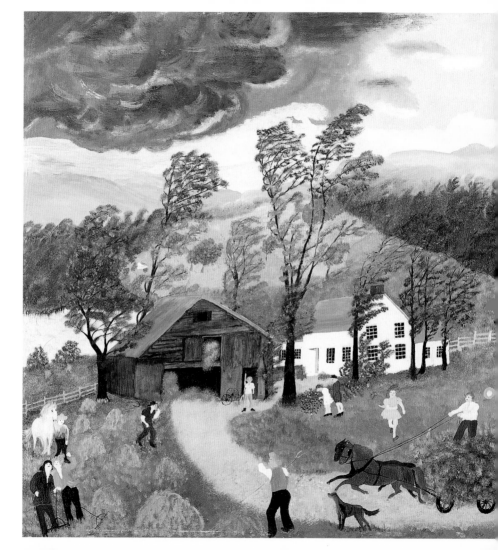

FAR LEFT
The Thunderstorm
1948. 20 ¾ x 24 ¾"
(52.71 x 62.87 cm)
Kallir 729

LEFT
Three details of
The Thunderstorm

"Cinematic" storytelling

OPPOSITE
A Beautiful World
1948. 20 x 24"
(51 x 61 cm)
Kallir 787

In the foreground of *The Thunderstorm*, Moses presents the dramatic human reaction to the oncoming deluge almost like sequential or simultaneous scenes in a movie. There is a mad rush to get the hay into the barn, and at middle distance, a black horse bolts in terror (see middle detail on page 75). The girl in the yellow dress is frozen in mid-run, while, behind her to the left, two other children seem oblivious to the commotion (see bottom detail on page 75).

Sound Byte:
"It takes a Grandma Moses to lift us out of our ruts, to make us understand the simple beauty which lies all about us in everyday living."
—*The Oakland Tribune*, 1949

Beauty, please

As its title suggests, *A Beautiful World* represents Grandma Moses's view of ideal harmony between humankind and nature. She once told an interviewer that it was the *pretty things* in life that, as an artist, she liked the best. Since much of 20th-century painting was difficult and pessimistic, some critics had a tendency to dismiss Grandma Moses's vision as simplistic. Yet there has been much art throughout the centuries that is accessible and optimistic. All art is in some sense an

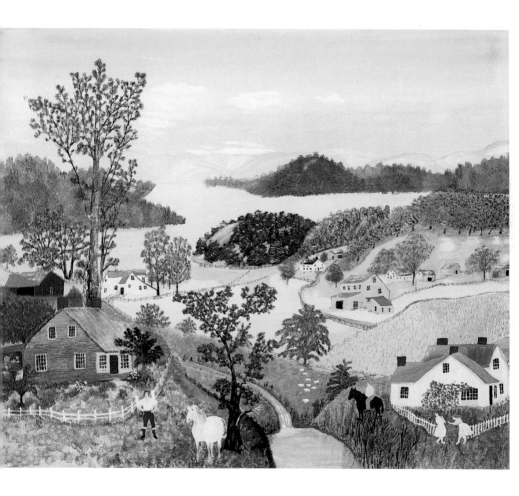

affirmation of life—an offering of the human spirit, however down-trodden, as proof that our thoughts and feelings are ever-precious and sometimes beautiful. This is the essence of Grandma Moses's genius.

Sound Byte:

"What's the use of painting a picture if it isn't something nice? I think real hard till I think of something real pretty, and then I paint it. I like to paint old-timey things, historical landmarks of long ago, bridges, mills, and hostelries, those old-time homes, there are a few left, and they are going fast. I do them all from memory, most of them are daydreams, as it were."
—GRANDMA MOSES, *My Life's History*, 1952

Fame and (almost) fortune

Moses was beloved by countless Americans—and eventually by people throughout the world—in large part because she refused to pay lip service to the elitism of the art world. Her no-nonsense attitude toward celebrity inspired genuine warmth in her admirers. Fame did little to change her lifestyle or her personality. "That, I am too old to care for now," she claimed.

Sound Byte:

"Why, those reporters were all right. You know how chickens come runnin' around when you go to the door to feed 'em? That's what those reporters made me think of. They were nice boys and girls."

—GRANDMA MOSES, *The New York Times*, 1949

Moses remained content on her farm in Eagle Bridge, rarely venturing into the big-city art centers. She did not like such trips. Her attitude toward money was similarly down-to-earth: The paintings should provide for a comfortable old age, but anything more than that seemed excessive. At first, she chided her dealer, Otto Kallir, for raising her prices, and returned the extra money he sent her. Eventually, however, she came to appreciate his professional wisdom, especially as the copyrighting of her artwork allowed her to reap additional benefits from reproduction royalties.

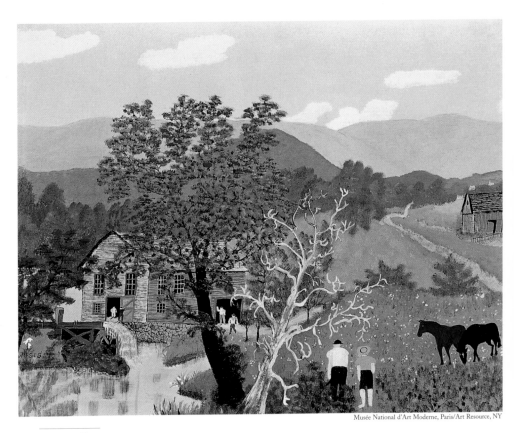

The Dead Tree
1948. 16 x 20"
(40.7 x 50.8 cm)
Kallir 792

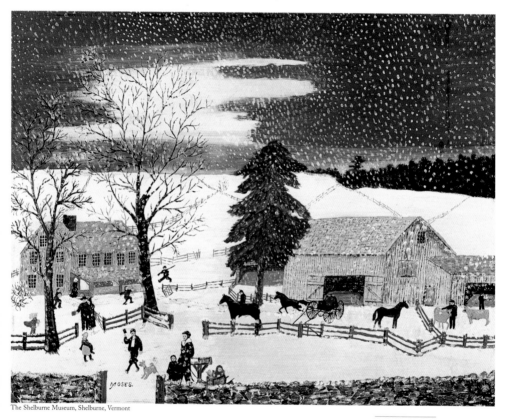

The Shelburne Museum, Shelburne, Vermont

The Mailman Has Gone
1949. 16 3/4 x 21 1/2"
(41.28 x 54.61 cm)
Kallir 818

Still, the art market in the 1940s and 1950s was not what it would later become. One thousand dollars then was a huge price for a painting. Moses could live well but not extravagantly on what she earned.

Inside out

Moses was basically a landscape painter, but certain memories and themes demanded an indoor setting. She knew this, and some of her patrons encouraged her to expand her repertoire to include interiors. The subject, however, did not come easily to her. Without the landscape to anchor the scene and provide an element of realism, her interiors rely almost wholly on the artist's command of abstract form and patterning. These qualities are used to maximum advantage in *The Quilting Bee*, wherein the colors and forms of the large quilt and the elaborate table setting play

The Quilting Bee
1950. 20 x 24"
(50.8 x 61 cm)
Kallir 883

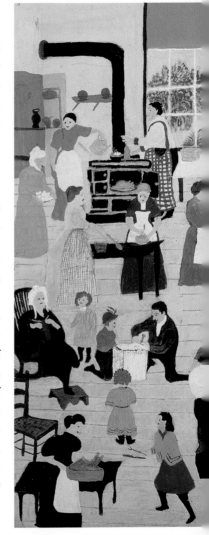

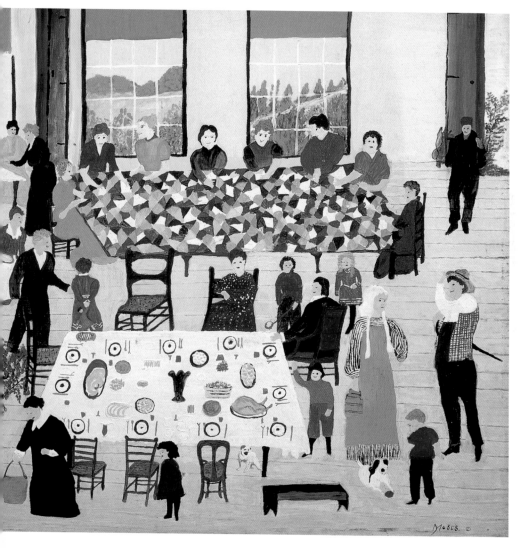

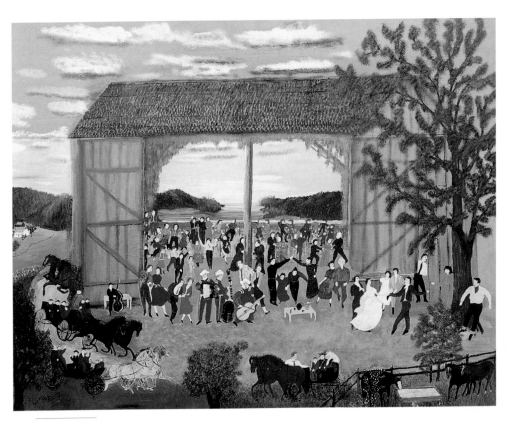

Barn Dance
1950. 35 x 45"
(88.9 x 114.3 cm)
Kallir 920

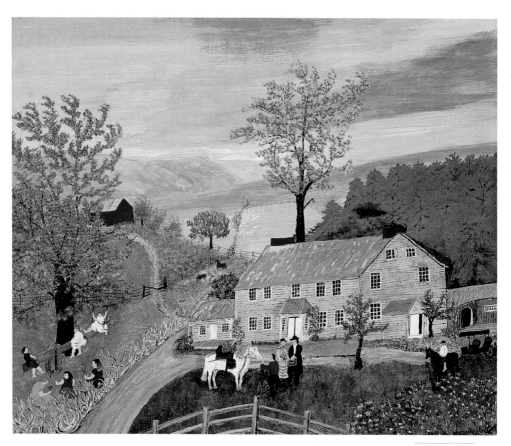

The Doctor
1950. 20 x 24"
(51 x 61 cm)
Kallir 957

off neatly against the bright clothing of the numerous bustling characters. Still, Moses could not resist adding a bit of nature beyond the tall, uncurtained windows.

Sound Byte:

"I tried that interior but did not like it, so I erased it. That don't [sic] *seem to be in my line. I like to paint something that leads me on and on into the unknown, something that I want to see away on beyond. Well, maybe I try again."*
—GRANDMA MOSES, 1948

Secrets of the Grandma Moses Style

OPPOSITE
July Fourth
1951
23 ⁷/₈ x 30"
(60.6 x 76.2 cm)
Kallir 999

You'll notice that there are a few striking features that help identify the style of Grandma Moses:

- She renders human and animal activity as abstract forms. Although she often copies the characters in her paintings from conventional illustrations, she eliminates all illustrative detail.

- The abstract figures in Moses's paintings become symbolic *Everyman* and *Everywoman* characters with whom viewers can easily identify.

- In contrast to her abstract rendition of anecdotal details, Moses paints nature realistically. The artist's sensitivity to the colors of season and time of day brings her landscapes to life. You can easily imagine

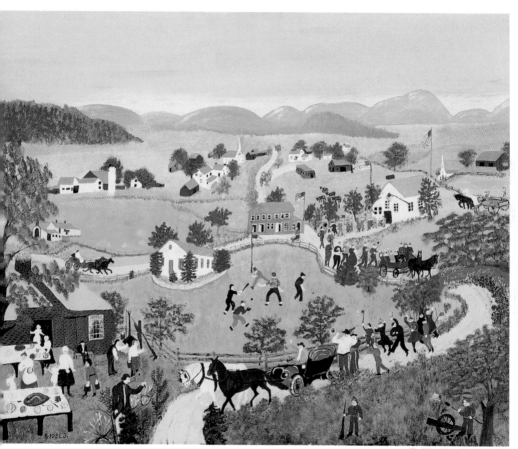

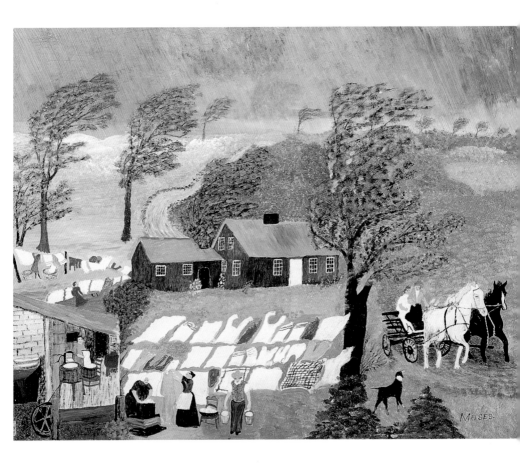

yourself walking around in a Grandma Moses landscape, smelling the newly mown hay or musty autumn leaves.

- Moses evokes the bygone days of her childhood in a highly generalized fashion. The figural elements in her paintings, with their reliance on stylized, abstract form and paucity of illustrative detail, *allude* to the past instead of *representing* it literally. Her depiction of the natural landscape, on the other hand, is fresh and of the moment. In this manner, Grandma Moses links the present with the past, emphasizing values that are immune to the ravages of time.

- Memory and hope are central to an understanding of Moses's art: By linking past and present, she creates works that seem to guarantee the future.

OPPOSITE
Taking in Laundry
1951
17 x 21 $^3/_4$"
(43.2 x 55.3 cm)
Kallir 967

Grandma's new digs

In 1951, when the creaky stairs in the old Moses farmhouse became too difficult for the artist to manage, her son Forest built her a ranch-style house across the street. The new house was probably the artist's biggest indulgence.

Moses and the media

The rags-to-riches saga of the elderly painter captured the American imagination. Facing the harsh realities of the Cold War era, the public took heart in a real-life tale that seemed to prove the old adage,

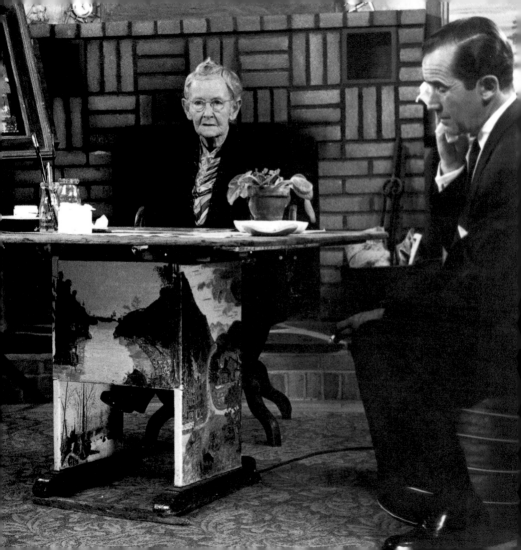

IT'S NEVER TOO LATE. The media never tired of repeating Moses's fairytale story. In 1953, she was featured on the cover of *Time* magazine. The dawning age of mass communications gave the public unprecedented access to Grandma Moses and her work. In addition to traveling exhibitions, books, and greeting cards, people could enjoy posters and even mural-sized reproductions, china plates, drapery fabrics, and a number of other licensed Moses products. By live-remote broadcast—which was then a technological marvel—Moses's voice was beamed out from her home in Eagle Bridge to the world at large.

In 1955, when color television was new, she was interviewed on CBS Television by legendary journalist **Edward R. Murrow** (1908–1965), who showed her art on the air. Moreover, the actress **Lillian Gish** (1896–1993), a former silent-screen star, portrayed Moses in one of the first televised docudramas.

OPPOSITE
Grandma Moses being interviewed for CBS Television by Edward R. Murrow
1955

Sound Byte:

"Dear Grandma,

It gives me a great deal of joy and happiness. I was a mental patient. I am feeling fine now. Looking forward to a new life. I feel I can do it and I will and must. When I know you did it, I feel I will also do it. You are my inspiration for life and love."

—A fan, writing in an Exhibition guest book, 1955

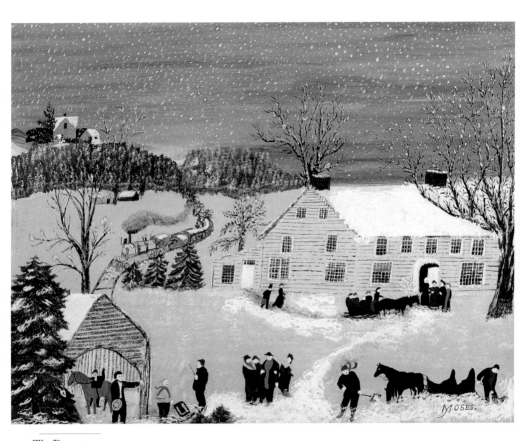

The Departure
1951. 17 x 22"
(43.2 x 55.8 cm)
Kallir 969

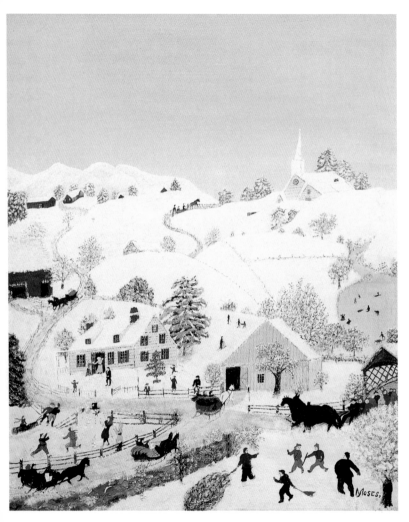

White Christmas
1954
23 3/4 x 19 3/4"
(60.33 x 50.17 cm)
Kallir 1162

Spooky, spooky!

As we've seen, Moses was never entirely comfortable painting interiors. One method she used to get around her discomfort was to paint cutaway, dollhouse-like views of houses. This allowed her to depict interior and exterior at once. She was always happier if she could imagine a scene in a natural setting. *Halloween* is one of her most successful such "dollhouse" pictures. The landscape background sets a mood of extreme spookiness. Clouds scud across the moon and trees glow silver in the darkness. The houses in the distance look haunted. The slightly discordant palette of white, gray, green, and orange underscores this sense of subliminal unease, which contrasts sharply with the merry goings-on in the fore- and middle ground. Moses's children were cheery pranksters, and *Halloween* records a number of typical Halloween escapades: little girls dressed as ghosts; boys on the roof stuffing pumpkins down the chimney, or rattling a cart of coals to make scary noises. Downstairs, the adults are preparing more sedate entertainment. Men are unloading barrels of cider, and a woman stokes the fire while children bob for apples.

Grandma Moses's Late Style

Although 80 at the time of her first one-woman exhibition, Grandma Moses lived on to enjoy a career of more than 20 years. During that time, she learned steadily from her work and grew as an artist. The

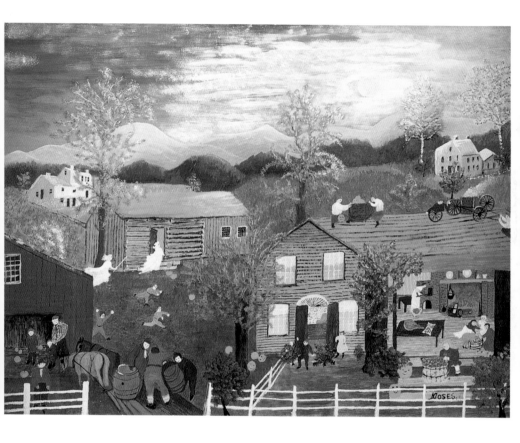

paintings created in the last years of her life are markedly different from those of the 1940s:

Rockabye (Self-Portrait)
1957. 11 7/8 x 16"
(30.1 x 40.6 cm)
Kallir 1303

- She used narrower, more horizontal boards, instead of the squarish format that had characterized much of her earlier work. The horizontal format facilitated greater compression of the compositional elements.

- Moses's brushwork became much looser; her forms, more abbreviated and condensed. She painted human and animal figures with far less precision than one finds in her works from the 1940s. She daubed the foliage erratically onto the trees and telegraphed her message with far greater immediacy.

- Moses's colors became brighter. The overall impression is more spontaneous and more expressive.

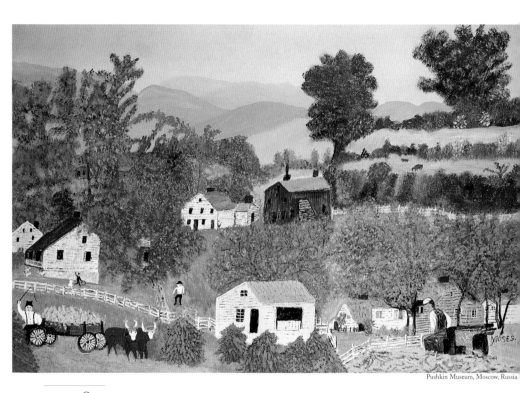

Corn
1958. 16 x 24 1/8"
(40.7 x 61.75 cm)
Kallir 1362

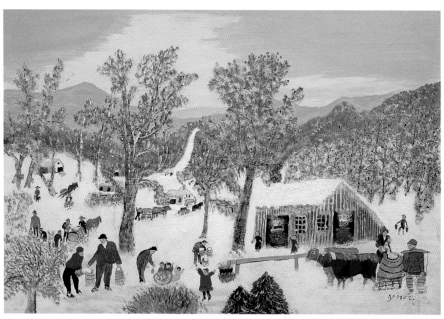

Doing it her own way

OPPOSITE
*So Long Till
Next Year*
1960. 16 x 24"
(40.7 x 61 cm)
Kallir 1461

Grandma Moses resisted attempts by outsiders to dictate to her in terms of style or subject matter, but she was open to new challenges. When someone once asked her to paint biblical pictures, she responded that she would not paint something "that we know nothing about," since she might as well paint something that would "happen a thousand years hence." However, despite her staunch adherence to the factual and true, fewer than two years before she died Moses was invited to illustrate a children's book, Clement C. Moore's famous poem "The Night Before Christmas." At first she resisted, for her art had always been drawn from lived experience, never from fantasy or imaginary events. But Moses liked the poem and knew it by heart. Although nearing her 100th birthday and in failing health, she agreed to take on the project.

Just as she had once risen to the challenge of painting interiors, Moses—even at the age of nearly 100—was ready to risk something completely untried. Unfortunately, she did not live to see the publication of *The Night Before Christmas*, which appeared in 1962.

So Long Till Next Year was one of 19 paintings that Moses created for *The Night Before Christmas* project. Although the work was not actually reproduced in the first edition of the book, it is in many ways the quintessential Christmas painting by an artist who was famous for such subjects. Unlike most of Moses's snowscapes, which are clearly

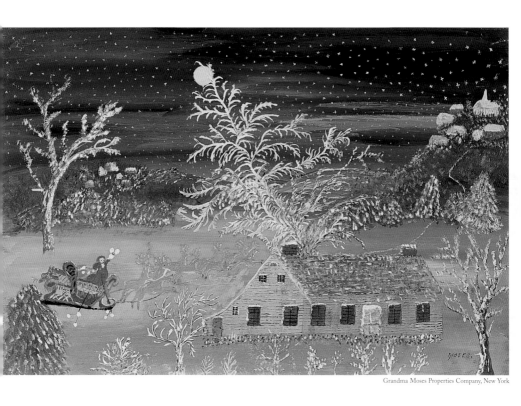

grounded in nature, the chilling-blue background of *So Long Till Next Year* immediately informs us that we are in the realm of the imagination. The painting demonstrates Moses's exceptional flexibility and versatility, as in the background scenery, which is etched in a frosty filigree, like icicles on a window pane.

For many years, Grandma Moses's *The Night Before Christmas* was an annual staple on the Captain Kangaroo television show. A redesigned edition was published in 1991.

Her last painting

Everyone rejoiced in Grandma Moses's longevity. In 1960, *Life* magazine sent noted photographer **Cornell Capa** (1911–1956), the founding director of the International Center of Photography (ICP), to do a cover story on the artist's 100th birthday. The national press celebrated that birthday almost like a holiday and New York's governor, **Nelson Rockefeller** (1908–1979), declared the occasion "Grandma Moses Day." The birthday fanfare was repeated the following year when Moses turned 101.

Grandma Moses continued to paint well into her 101st year, although during the last few months of her life she was too weak to work. *Rainbow*, executed in June 1961 and shown on pages 104–105, is generally considered to be her last finished picture. As such, it is an

amazing distillation of the artist's world view as well as of her late style, in which her wild, nearly expressionistic handling of paint facilitates a joyous free-for-all of color.

Figural vignettes, once so clearly set off from the landscape, here merge with their surroundings. Nature and humankind are at last one. Moses was no longer concerned with representational accuracy in her use of color. The emotional impact had become more important to her. The exuberant swish of the scythes, candy-striped in yellow, white, and red, and the spun-sugar puff of pink flowers, out of which a hay wagon rises like a small triumphant chariot, are presented as bright symbols in paint, tokens of peace, an offering of hope.

On December 13, 1961, several months after her 101st birthday, Grandma Moses passed away.

Grandma Moses and the art world

Moses's initial rise to prominence had been predicated on a broad-based interest in the work of self-taught painters. However, her extreme popularity eventually separated her from the ranks of other self-taught artists and their more circumscribed audience. Fame also distanced Moses from the art-world elite that had championed folk art in its more obscure moments. Some found Moses's success suspect, as though she were literally too good to be true. Others believed, quite

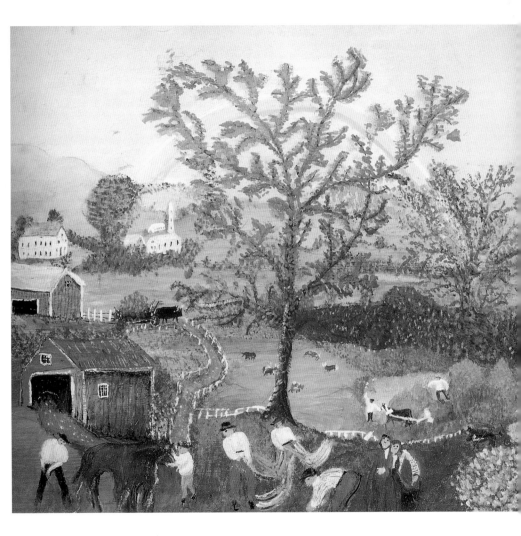

FAR LEFT
Rainbow
1960. 16 x 24"
(40.7 x 61 cm)
Kallir 1511

LEFT
Three details of
Rainbow

simply, that no truly great artist could be as popular as Grandma Moses. The art world, ironically, has often viewed quality and popularity as mutually exclusive concepts.

OPPOSITE
Detail of
*Mountain
Landscape*
1939 or earlier
Kallir 33W

Moses's comparatively realistic style was juxtaposed—by both her supporters and her detractors—with the Abstract Expressionist movement of **Jackson Pollock** (1912–1956), **Willem de Kooning** (1904–1997), and their peers that was concurrently in ascendancy. The American public as a whole did not respond favorably to abstract art, which President Truman called "ham and eggs art." Moses's paintings were championed as an alternative to what one critic termed "the lanes of abstraction and intellectualized distortion."

Sound Byte:
"Europeans like to think of Grandma Moses as representative of American art. They praise our naïveté and integrity, but they begrudge us a full, sophisticated artistic expression. Grandma Moses represents both what they expect of us and what they are willing to grant us."
—The New York Times, 1950

On the other hand, as the United States became a global superpower in the Cold War era, the art world felt a pressing need for a sophisticated art that could hold its own against European modernism.

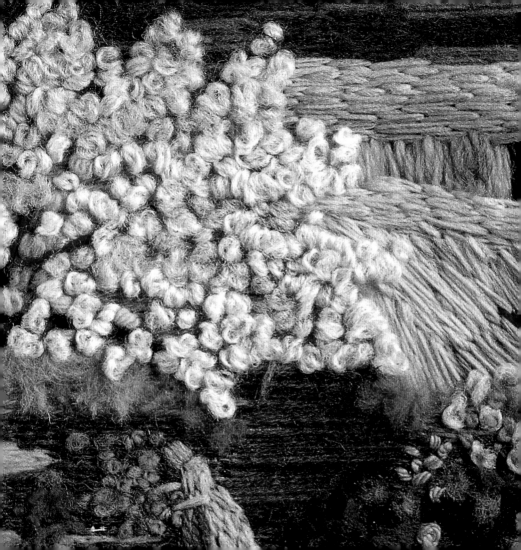

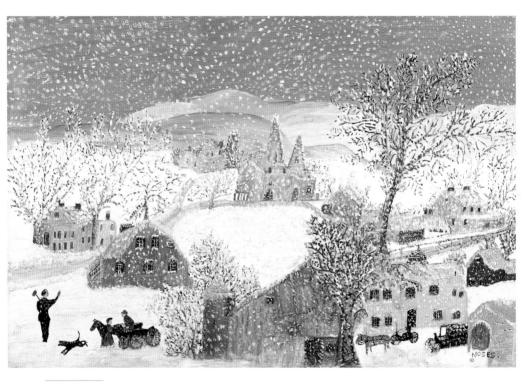

Get Out on the Sleigh. 1960
16 x 24"
(40.7 x 61 cm)
Kallir 1474

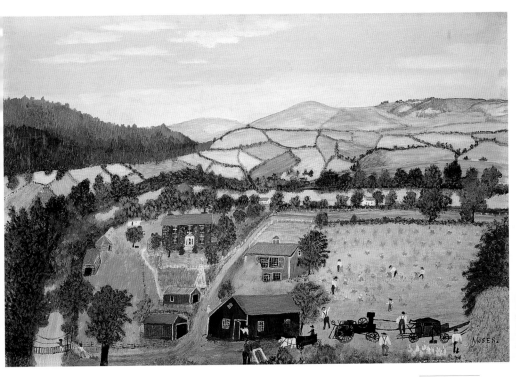

Calhoun
1955. 16 ³/₄ x 24"
(42.55 x 60.96 cm)
Kallir 1200

OPPOSITE
Wash Day
1945
17 $^{3}/_{4}$ x 23 $^{1}/_{2}$"
(45.1 x 59.7 cm)
Kallir 498

Folk art—quaint and provincial—did not fit the bill. Indeed, the art establishment's support of folk art had never been universally welcomed. Trained American artists felt they were being passed over in favor of European modernists and self-taught bumblers. After MoMA director Alfred Barr nearly lost his job over a controversial 1943 retrospective of the self-taught painter **Morris Hirshfield** (1872–1946), Barr abandoned folk art and threw his lot in with the abstractionists. The rest of the art-world elite followed suit.

Grandma Moses Today

Decades after her death, it is now easier to place Grandma Moses's work in perspective than it was when she was at the height of her fame:

- A resurgence of interest in contemporary self-taught artists—often called *Outsiders*—has prompted a 21st-century reexamination of Moses's life and works.

- The white male Eurocentric artistic canon has been expanded to include works from a large variety of nontraditional sources.

- Popularity has lost its stigma now that contemporary artists routinely become media superstars.

- As trained artists repeatedly borrow from pop culture, the iconographic boundaries between high and low art have become blurred.

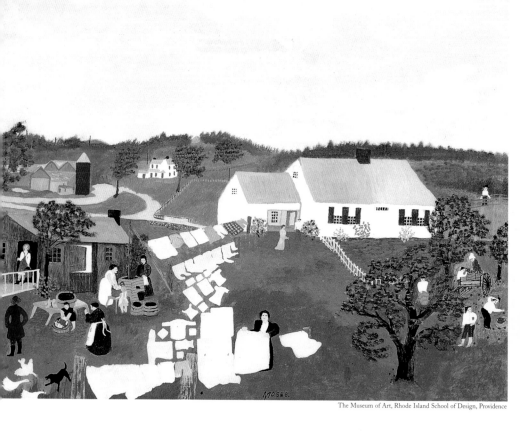

While her celebrity status has faded since her passing, Moses's art remains more vital than ever. Few artists—trained or otherwise—have managed to invent an expressive idiom as enduring and original as the Grandma Moses style. Stay tuned, because she is about to be rediscovered by a new generation of young admirers.

Sound Byte:
"Not all the carefully maneuvered promotion in the world could have put Grandma Moses over, any more than it has succeeded in bringing fame to some other American Sunday painters favored by the attention of great museums and shrewd dealers. Grandma became world famous because her paintings were an affirmation of life in a time when the world was desperately seeking affirmation. They are witness that man, if he believes in something beyond himself, if he works tirelessly, if he learns with experience, can overcome great odds."
—EMILY GENAUER, *The New York Herald Tribune*, 1961

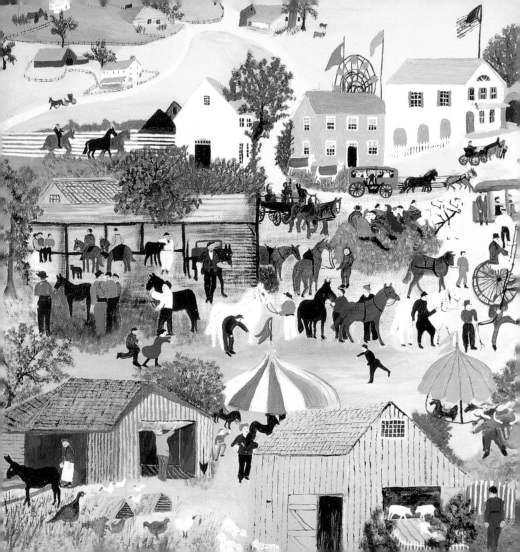

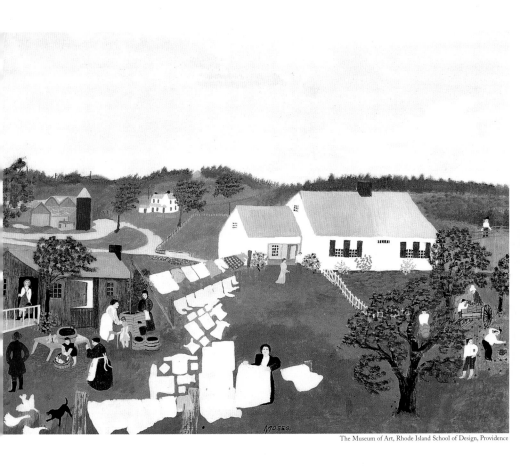

While her celebrity status has faded since her passing, Moses's art remains more vital than ever. Few artists—trained or otherwise—have managed to invent an expressive idiom as enduring and original as the Grandma Moses style. Stay tuned, because she is about to be rediscovered by a new generation of young admirers.

Sound Byte:

"Not all the carefully maneuvered promotion in the world could have put Grandma Moses over, any more than it has succeeded in bringing fame to some other American Sunday painters favored by the attention of great museums and shrewd dealers. Grandma became world famous because her paintings were an affirmation of life in a time when the world was desperately seeking affirmation. They are witness that man, if he believes in something beyond himself, if he works tirelessly, if he learns with experience, can overcome great odds."

—EMILY GENAUER, *The New York Herald Tribune*, 1961

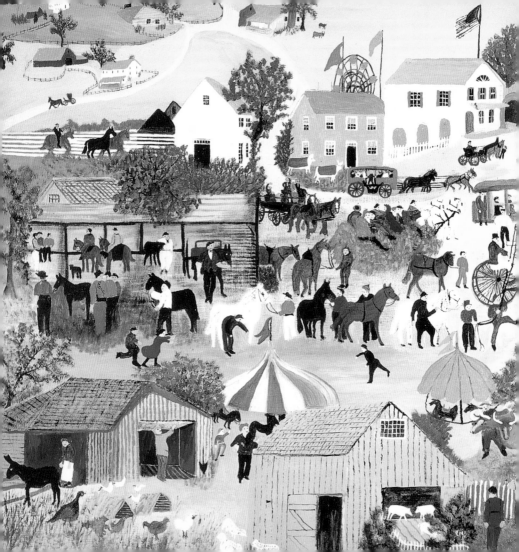